Drawing Geometric Solids

How to Draw Polyhedra from Platonic Solids to Star-Shaped Stellated Dodecahedrons

Deltaspektri

Drawing Geometric Solids: How to Draw Polyhedra from Platonic Solids to Star-Shaped Stellated Dodecahedrons

Sympsionics Design

ISBN 978-952-68217-3-3

Published by
Deltaspektri
Espoo, Finland

Contents

Drawing and coloring the images

Draw the images initially with a pencil. You will often need some auxiliary lines while drawing, which will eventually be erased. Colored pencils are good for making the final lines stronger and coloring the image.

Coloring Techniques

The images in this book were colored using the following techniques.

You can hold the colored pencil in the regular way, like a normal pencil. The coloring movement can be either back-and-forth or somewhat circular. An image created using this technique can be seen on page 31.

You can also hold the colored pencil almost horizontally at an angle and use the side of the tip for coloring. This technique is illustrated in the image on the right, and an example of coloring performed in this way can be seen on page 35. You can increase the glow-effect achieved in coloring by adding a layer of light color on top of a darker color.

You can sharpen a colored pencil and drop the shavings onto the picture. To add further color, simply press down on the shavings and move your finger around. An example of the results of this technique can be seen on page 45.

Dual Polyhedra

In many of the images in this book, a dual of a polyhedron is drawn inside the polyhedron by connecting the middle points of the solid's faces to each other. This is explained in more detail in the corresponding drawing instructions. If a polyhedron has a certain number of faces, its dual has the same number of vertices. The number of edges is the same in both objects.

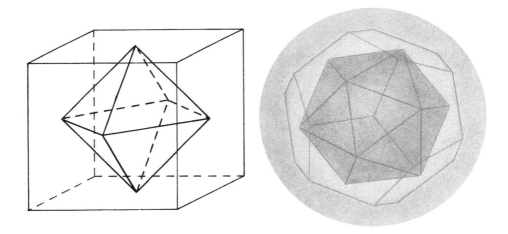

On the left: A cube and an octahedron are each other's dual solids
On the right: A dodecahedron and an icosahedron are each other's dual solids

A Tetrahedron Inside a Tetrahedron

You can start drawing three-dimensional solids by using a model. Use a ruler to draw straight lines. The tetrahedron, which is the simplest of the Platonic solids, is a good choice for the first object to be drawn from a model. Inside your drawing of a tetrahedron you can draw its dual polyhedron, which is also a tetrahedron.

When drawing a dual of a Platonic solid inside the solid, all the vertices have to be visible in the picture, even the ones on the far side of the object. A tetrahedron can be easily drawn from a three-dimensional model so that all the vertices are visible. Instructions for constructing a three-dimensional tetrahedron can be found in appendix 2 on page 66.

Place the model on the table so that all the vertices are visible to you. Mark the positions of the vertices on the paper. Connect the points with a ruler. Use a solid line for the edges at the front and a dashed line for the one at the back.

To draw the dual polyhedron, you need to find the middle points of the faces. Use a ruler to find the midpoint of each edge of the tetrahedron and mark them in the picture. Next, place the ruler on one face so that it connects a vertex with the opposing edge's midpoint. In the illustration on the next page, a dashed line is used to show the correct positions of the ruler. When the ruler is in place, draw a short straight line where you estimate the middle point of the face to be. Staying on the same face, move the ruler so

that it connects a different vertex to the midpoint of its opposite edge. Again, draw a short line near the middle point of the face. If the two lines you drew do not intersect, return the ruler to where it was and extend the lines. The point where the two lines intersect is the middle point of the face.

You can check whether you have found the correct spot by placing the ruler on the face of the tetrahedron, so that it connects the third vertex to its opposite edge. The ruler should cross the same spot found in the previous steps. Mark the middle point with a dot and erase the remaining auxiliary lines. Repeat the process for the remaining three faces.

The dual of a tetrahedron is also a tetrahedron. You can draw a small tetrahedron inside a larger one by connecting the middle points of the faces to each other. Use a solid line for the frontal faces and a dashed line for the one facing away.

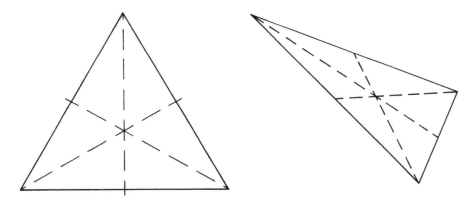

Finding the middle point of a single face

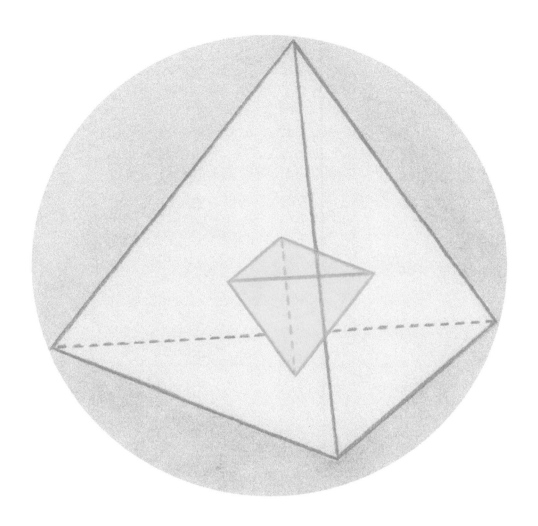

A tetrahedron inside a tetrahedron

Drawing a tetrahedron inside a cube

You can form a tetrahedron inside a cube if you draw a diagonal on each of the cube's faces. Start by drawing a cube according to the instructions on page 16.

Begin at the lower right corner of the cube and draw three diagonals on the cube's faces, as shown below in the picture on the left. Connect the other ends of the diagonals with lines as shown in the picture on the right. Use a dashed line on the furthermost face on the far side of the solid.

You can decide whether to erase the cube or leave it in the picture.

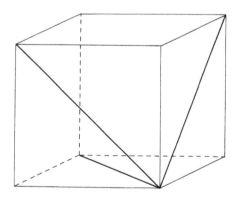 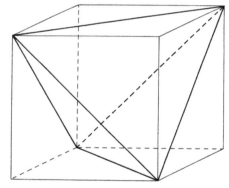

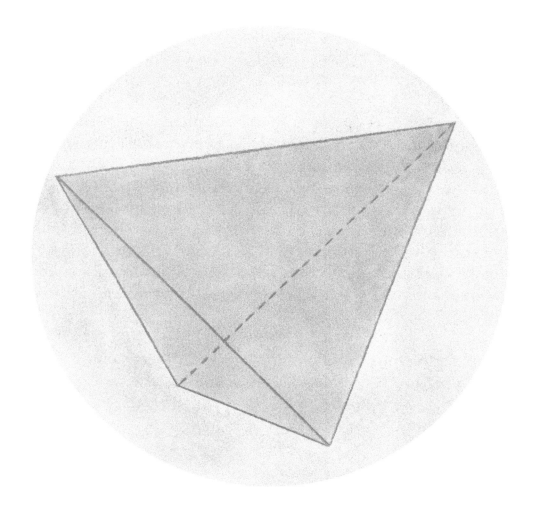

A tetrahedron

A Tetrahedron Inside a Tetrahedron Inside a Cube

Start by drawing a tetrahedron inside a cube as shown on page 10. To draw a smaller tetrahedron inside it, you will need to find the middle points of the triangle-shaped faces. First, use a ruler to find the midpoint of each side of one of the triangles and mark them.

Place a ruler over one face, so that it touches one vertex and the midpoint of the opposite edge. Draw a short line where you estimate the middle of the triangle to be. Then, move the ruler over the same face to touch another vertex and the midpoint of its opposite edge. Draw a short line where you estimate the middle of the face to be. If the two lines do not meet, return the ruler to where it was and draw longer lines. Mark the intersection point with a dot and erase the auxiliary lines. Repeat the process for the remaining three faces.

Connect the four middle points of the faces to each other as in the picture below. Draw one of the lines with a dashed line because it is facing away.

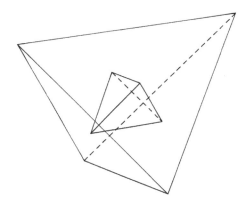

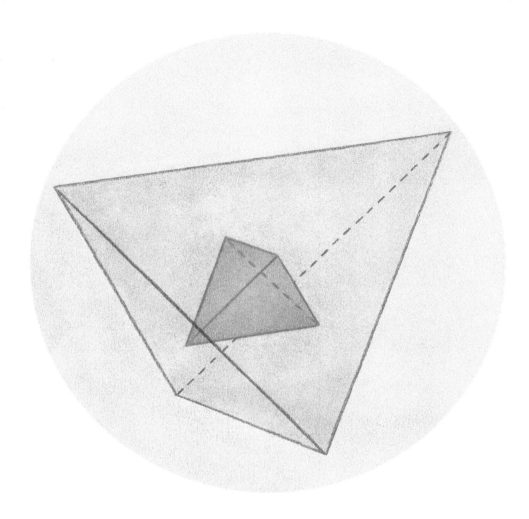

A tetrahedron inside a tetrahedron

An Octahedron Inside a Cube

A cube and an octahedron are each other's dual solids. A cube has six faces and an octahedron has six vertices. A cube has eight vertices and an octahedron has eight faces. They both have twelve edges.

You can draw an octahedron inside a cube by connecting the middle points of the cube's faces. A cube can be viewed from different angles. In the example on the next page, you can see a cube which has no horizontal edges. It is easier to draw a cube whose front face is drawn as a square. All edges showing depth can then be drawn at the same angle. This kind of drawing of a solid is called a cavalier projection. Instructions for drawing a cavalier projection of a cube and an octahedron inside it can be found as part of the transformation series on pages 16–25. The instructions for the cube are on page 16 and those for the octahedron are on page 24.

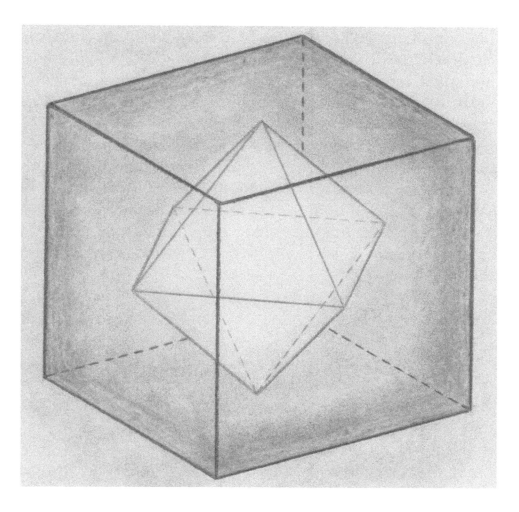

An octahedron inside a cube

A Transformation Series From a Cube to an Octahedron

The following instructions describe how you can draw a transformation from a cube to an octahedron. The series has five images. The first image is a cavalier projection of a cube. The edges showing depth all have the same angle, and their length is half the length of the horizontal and vertical edges. The angle between the left side of the horizontal edge and the edge showing depth will be somewhere between 25 and 35 degrees. Although 45 degrees is often used for a cavalier projection, the images you draw for this transformation series will be clearer if you use a smaller angle. Draw the edges at the front with a solid line and the edges at the back with a dashed line. You can also decide to leave the edges at the back invisible in the final image.

Image 1: A cube

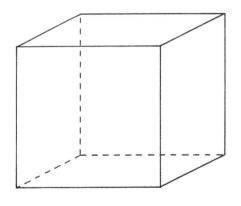

Start by drawing a square with a side length of 4 inches (10 cm). Draw lines, showing the depth from each corner, in a rightwards and upwards direction, all with the same angle (for example 30 degrees). The length of the lines showing depth will be 2 inches (5 cm). Connect the other ends of the lines showing depth, so that you obtain a square for the back face. This is the first image of the series. Start drawing the other four images by drawing an identical cube, which you will later erase.

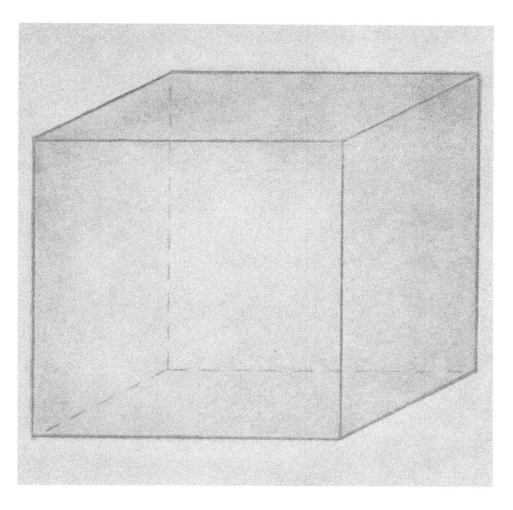

A cube

Image 2: A Truncated Cube

Draw a cube, with edges 4 inches (10 cm) long, by following the instructions on page 16. Mark two points on each edge at 1.2 inches (2.9 cm) from the vertices. In the case of the lines showing depth, draw them 0.6 inches (1.5 cm) from the vertices. You can see the points in the picture below on the left.

Then, connect the points close to the same vertex as in the pictures below. This will cut off the corner of the cube. The large faces will be regular octagons and the small faces will be equilateral triangles. Erase the unneeded lines from the corners of the cube.

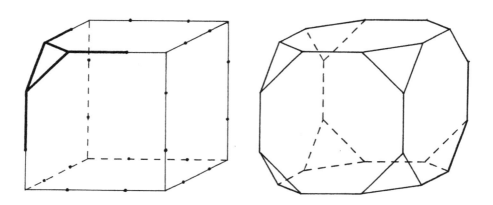

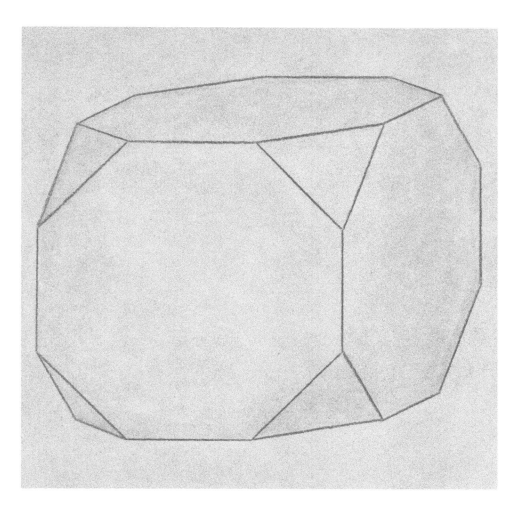

A truncated cube

Image 3: A Cuboctahedron

Start by drawing a cube (p. 16). Mark the midpoints of all edges of the cube with a ruler. Connect up the midpoint of the nearby edges as in the pictures below. Erase the lines of the cube.

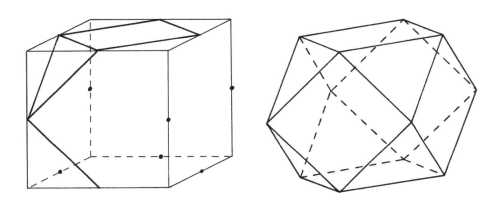

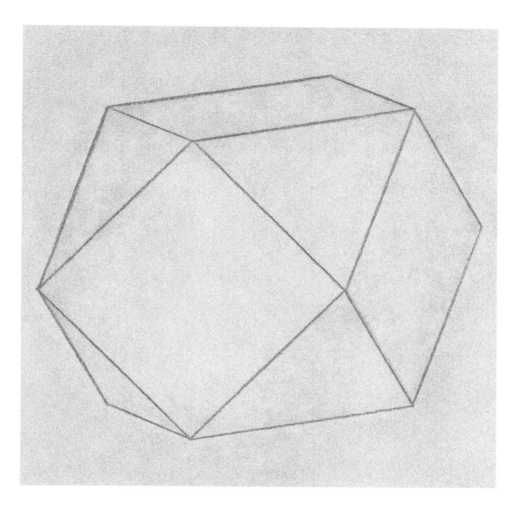

A cuboctahedron

Image 4: A Truncated Octahedron

Draw a cube, with edges 4 inches (10 cm) long, by following the instructions on page 16. Mark points on each edge 1 inch (2.5 cm) from the vertices (one fourth of the edge). In the case of the lines showing depth, draw them 0.5 inches (1.25 cm) from the vertices. You can see these points in the picture below on the left.

Connect points at the edge of the face to form a small square in the middle of the face. This is illustrated in the picture on the left. Do this for all edges, so that there is a small square in the middle of each face. Then, connect the squares of the adjacent faces to each other. The result will be regular hexagons as in the pictures below. The faces of the solid are squares and regular hexagons. Erase the lines of the cube.

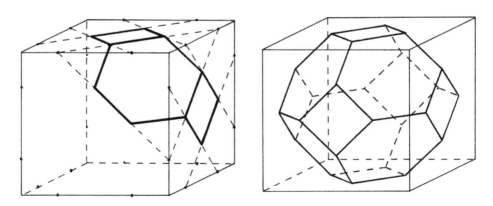

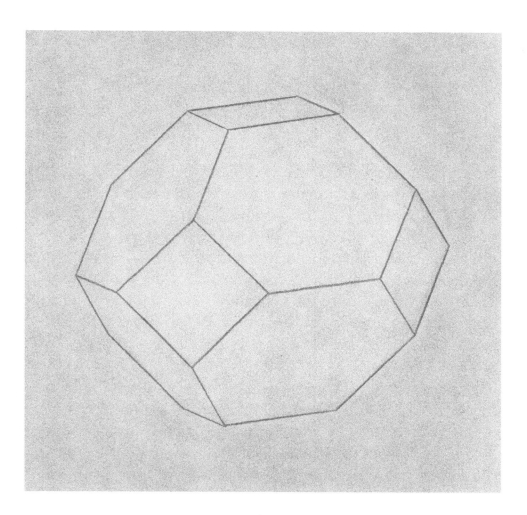

A truncated octahedron

Image 5: An Octahedron

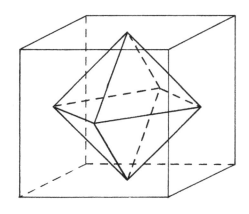

Draw a cube (p. 16). To draw an octahedron inside it, find the middle points of the cube's faces. You can do so by placing a ruler over the face to form a diagonal connecting one corner to the other. Draw a short line around the middle point of the face. Move the ruler to touch the other two corner points of the same face. Again, draw a short line roughly where you think the middle point will be. The middle point of the face is where the two lines meet. Mark it with a dot and erase the lines. Do this for all faces of the cube. Finally, connect the middle points of the adjacent faces to each other. The result will be four lines meeting at each middle point. When the octahedron is ready, erase the cube if you prefer.

It is also possible to draw a cube inside an octahedron in the same way. You can find the middle points of the faces of an octahedron in the same way as for a tetrahedron (p. 7–8). Connect the middle points to form a cube. You can see a cube inside an octahedron on page 26.

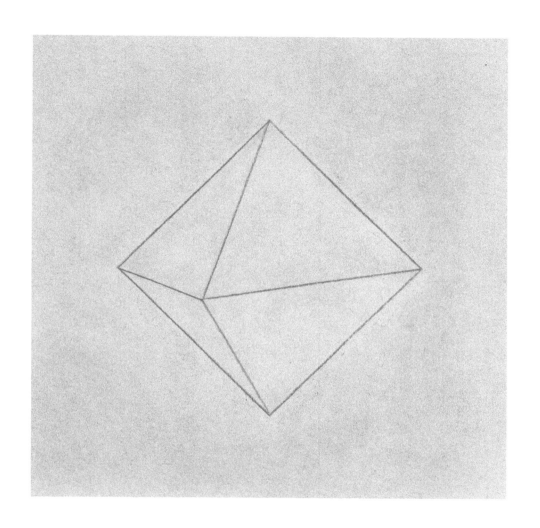

An octahedron

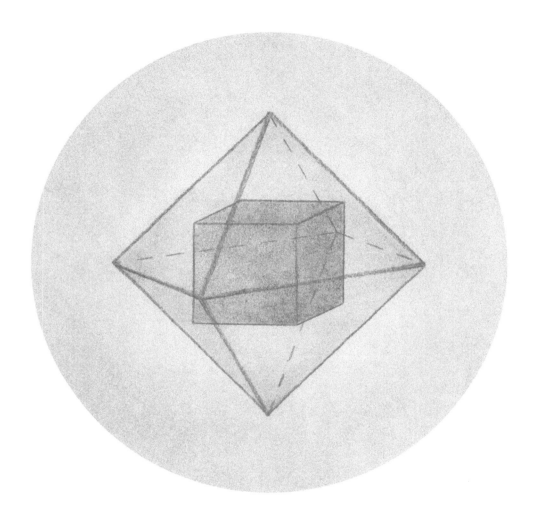

A cube inside an octahedron

A Stellated Octahedron

1. Draw a circle and a regular hexagon inside it. You can do this by marking the origin of the circle, drawing a circle with a radius of 3 inches (7.5 cm), and drawing a hexagon by following the instructions on page 51.

Connect the corners of the hexagon to form diagonals. Draw half of the diagonal with a solid line and the other half with a dashed line, as in picture 1. You can now see a cube in an isometric orthogonal projection. The solid lines are at the front, and the dashed lines are at the back. (Picture 1)

2. Continue connecting the corner points of the hexagon to form two equilateral triangles, which will form a star. (Picture 2)

3. Connect the three points close to the middle of the image to form a triangle, as in picture 3. Finally, erase any unneeded lines. (Picture 3)

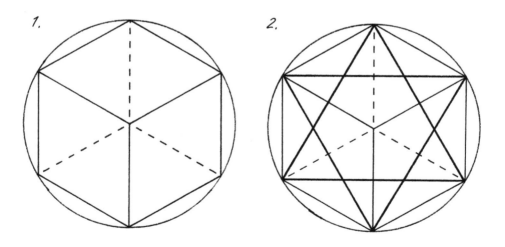

3.

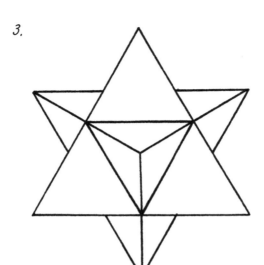

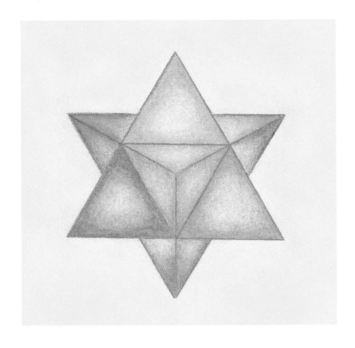

A stellated octahedron.

A Small Stellated Dodecahedron

1. Draw a point and use it as the origin of a circle with a radius of 3 inches (7.5 cm). Draw five radii so that the angles between them at the center are 72 degrees. Use a ruler and draw marks on the circle's circumference, where each radius would reach if you continued drawing it to form a diameter. Connect the points on the circumference to form a regular decagon. (Picture 1)

2. Start connecting the five points on the circumference where the radii do not touch: connect each of these points to other points on the circumference except to the points next to them, the points next to those, and the opposite points. (Picture 2)

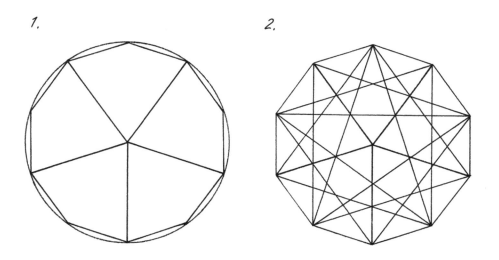

1.

2.

3. Take a colored pencil and color five areas as in picture 3. You can erase the lines inside those areas first. (Picture 3)

4. Take a different color and color five new areas, which have been marked with light gray in picture 4. Again, take a new color and continue coloring in a similar way. You will need six different colors altogether. You can find the places for the other colors in the picture on the next page.

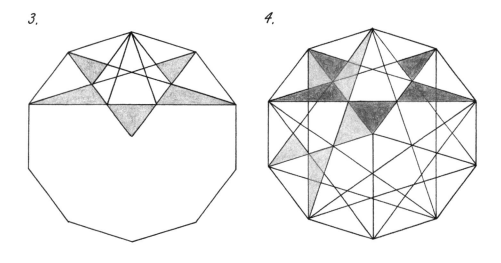

3.

4.

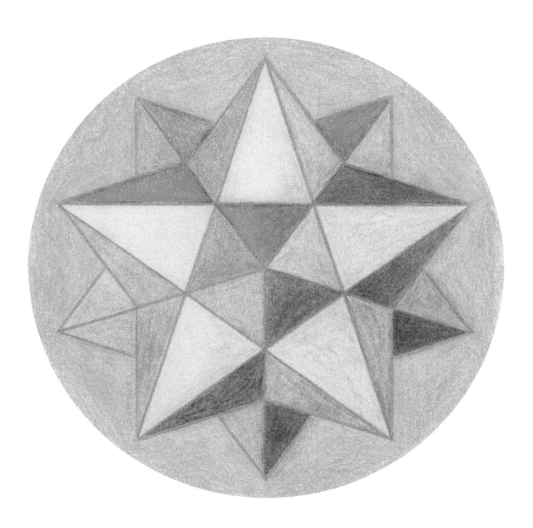

A small stellated dodecahedron

A Great Stellated Dodecahedron

1. Draw a point and use it as the origin of a circle with a radius of 3 inches (7.5 cm). Draw five radii so that the angles between them at the center are 72 degrees. (Picture 1)

2. Use a ruler and draw marks on the circle's circumference at the points which each radius would reach if you continued drawing it to form a diameter. Connect every second of these new points to each other. The lines will form a fivefold star, as in the picture on the right. You can erase the unneeded lines from the middle, or not draw them in the first place. (Picture 2)

1. 2.

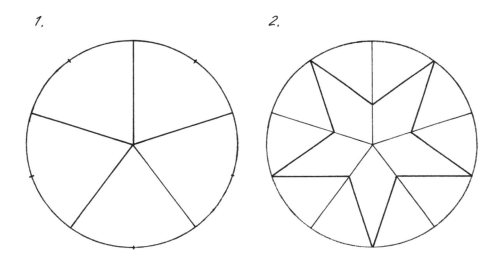

3. Continue by drawing new lines as in picture 3. These lines will be formed when you connect the points along the circumference to each other, but do not draw the middle part of the line. The new lines will form a fivefold star behind the first star. (Picture 3)

4. Next, find the apexes of the smaller star that will be formed in the middle. You will find them by connecting every fourth point on the circumference, as shown with a dashed line in picture 4. Instead of drawing the whole line, you could draw just a short mark where the apex of the star will be. Continue the radii of the original circle all the way up to this mark. (Picture 4)

Alternatively, a more precise way of finding the marks for the apexes is by using a golden ratio. Measure a golden ratio between the length from the center to the mark and the radius of the original circle. You can do this by following the instructions on page 36 (step 1) or 49–50.

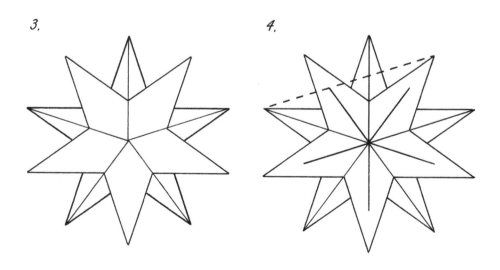

3.

4.

5. Draw the sides of the small star by connecting the apexes to the intersection points where the sides of the first star meet. (Picture 5)

6. Color the areas shown in picture 6 with the same color. Then, take a new color and continue to color in a similar way. You will need six different colors altogether. You can see the areas for different colors in the picture on the next page.

5.

6.

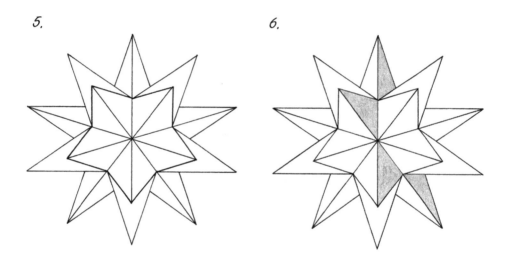

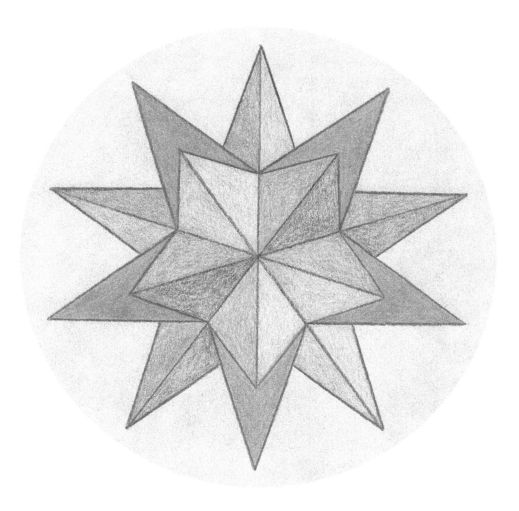

A great stellated dodecahedron

A Dodecahedron and an Icosahedron

A Dodecahedron

1. Draw a point and use it as the origin of two circles with radii of 1.85 inches (4.6 cm) and 3 inches (7.5 cm). The ratio of these radii is a golden section.

2. Draw ten marks with equal intervals on the circumferences of both circles as demonstrated in pictures 1 and 2. You can do this by using a protractor to draw angles at the center of 36 degrees. (Pictures 1 and 2)

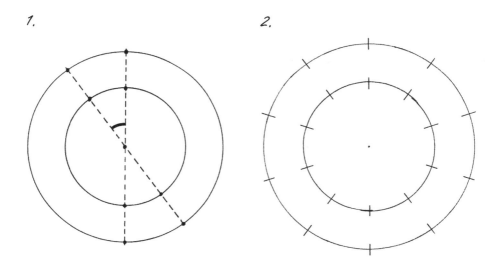

1.

2.

3. Connect the points of the outer circle to form a decagon. Connect every second point of the inner circle to form a pentagon. Connect the vertices of the pentagon to the closest vertex of the decagon. The dodecahedron is now ready, and you can choose whether to draw the lines at the back. (Picture 3)

4. Draw the lines at the back by using a dashed line to connect the remaining marks on the inner circle to form another pentagon. Finally, connect the vertices of the new pentagon to the closest vertex of the decagon with a dashed line. Erase any unneeded lines. (Picture 4)

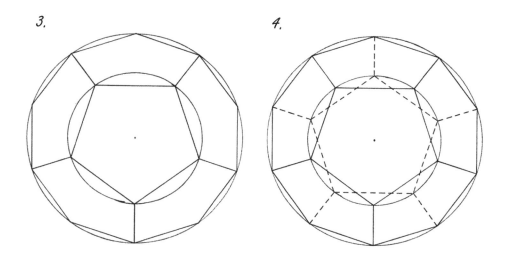

3.

4.

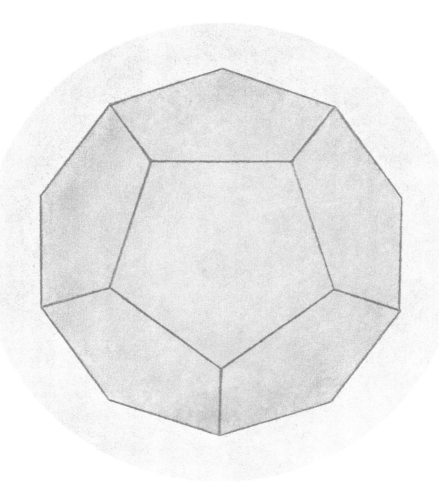

A dodecahedron

An Icosahedron

1. Draw a point and use it as the origin of two circles with radii of 1.85 inches (4.6 cm) and 3 inches (7.5 cm). The ratio of these radii is a golden section. Draw six marks at equal intervals on the circumferences of both circles as demonstrated in picture 1. You can do this by using a protractor to draw angles at the center of 60 degrees. (Picture 1)

2. Connect the points of the outer circle to form a hexagon. Connect every second point of the inner circle to form an equilateral triangle. (Picture 2)

1.

2.

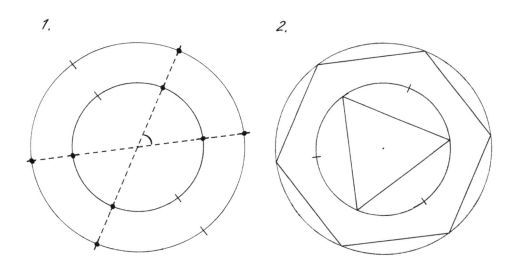

3. Connect each vertex of the equilateral triangle to the three closest vertices of the hexagon as in picture 3. The icosahedron is now ready, and you can choose whether to draw the lines at the back. (Picture 3)

4. Draw the lines at the back by using a dashed line to connect the remaining marks on the inner circle to form another equilateral triangle. Finally, use a dashed line to connect the vertices of the new equilateral triangle to the three closest vertices of the hexagon. Erase any unneeded lines. (Picture 4)

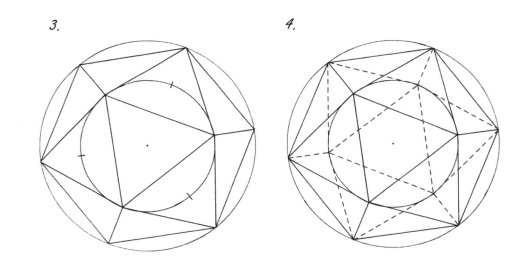

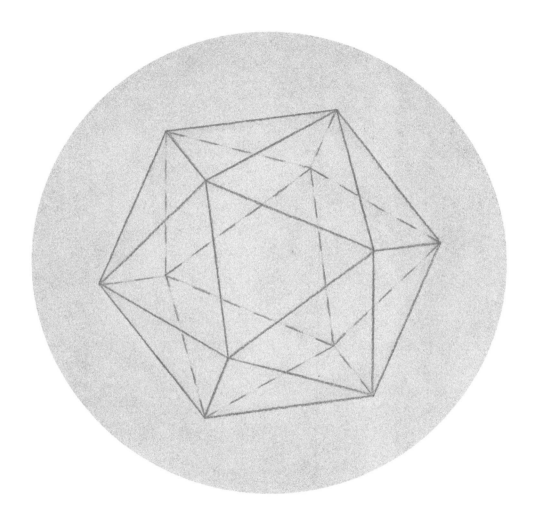

An icosahedron

A Dodecahedron Inside an Icosahedron

A dodecahedron is a dual solid of an icosahedron. You can draw it inside an icosahedron by connecting the middle points of the faces. It is also possible to draw an icosahedron inside a dodecahedron in the same way.

Draw an icosahedron by following the instructions on the previous pages, so that the lines at the back are visible as in the picture below.

Then, find the middle points of the faces. To find the middle point of one face, you will need the midpoints of two edges. Find them with a ruler. Then, place the ruler over the face so that it connects the midpoint of one edge and its opposite vertex. Draw a short line where you would estimate the middle point of the face to be. Then move the ruler over the same face but in another direction, so that it touches the midpoint of another edge and connects the edge to its opposite vertex. Again, draw a short line at about the middle point of the face. The middle point of the face is where the two short lines meet.

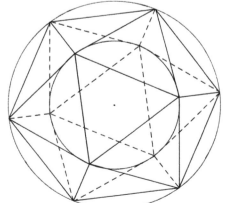

Find the middle points of all faces, including the ones at the back of the shape. Erase any unneeded lines.

Draw a dodecahedron by connecting the middle points of the faces as in the picture on the next page.

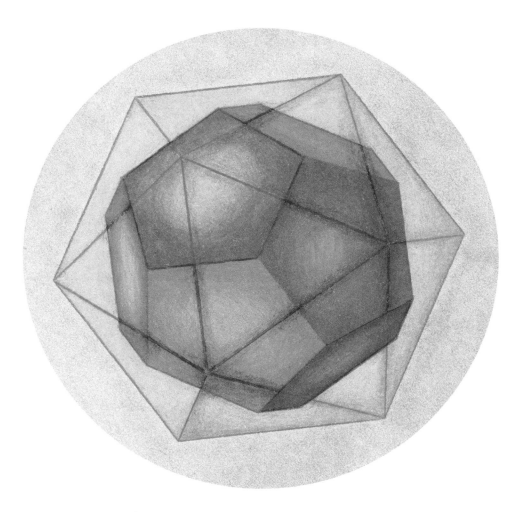

A dodecahedron inside an icosahedron

An Icosahedron Inside a Dodecahedron

Draw a dodecahedron inside an icosahedron by following the instructions on the previous pages, so that the lines at the back are visible as in the picture below. You may choose to erase the icosahedron around it.

Then, find the middle points of the faces. To find the middle point of one face, you will need the midpoints of two edges. Find them with a ruler. Then, place the ruler over the face so that it connects the midpoint of one edge and its opposite vertex. Draw a short line where you would estimate the middle point of the face to be. Then move the ruler over the same face but in another direction, so that it touches the midpoint of another edge and connects the edge to its opposite vertex. Again, draw a short line at about the middle point of the face. The middle point of the face is where the two short lines meet.

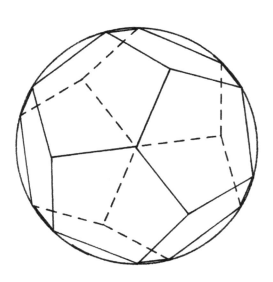

Find the middle points of all faces, including the ones at the back of the shape. Erase any unneeded lines.

Draw an icosahedron by connecting the middle points of the faces as in the picture on the next page.

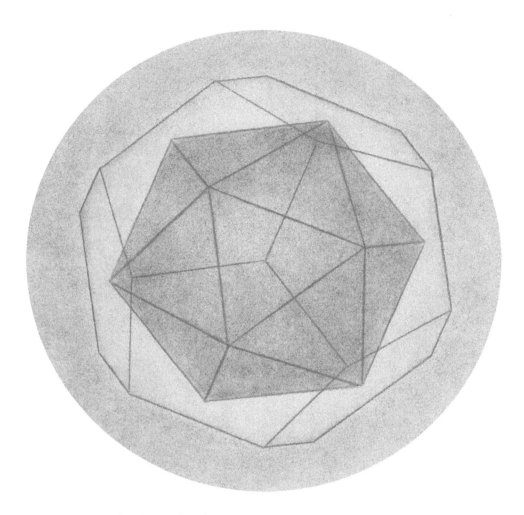

An icosahedron inside a dodecahedron

The Golden Rectangles Inside an Icosahedron

Draw an icosahedron by following the instructions on pages 39–41. Draw the lines at the back with a dashed line.

You can draw golden rectangles inside an icosahedron. A golden rectangle is a rectangle with two sides in a golden ratio. This means that the ratio of the longer and shorter sides is around 1.618. You can find out more about the golden ratio on page 48.

You can find the rectangles by connecting the ends of the edges on the opposite sides of the icosahedron to each other. For example, to draw the red rectangle on the next page, connect the parallel edges at the top and bottom with vertical lines. To draw the green and violet rectangles, connect the parallel edges on the opposite sides of the solid in the same way. Note how the three rectangles meet in the middle of the image.

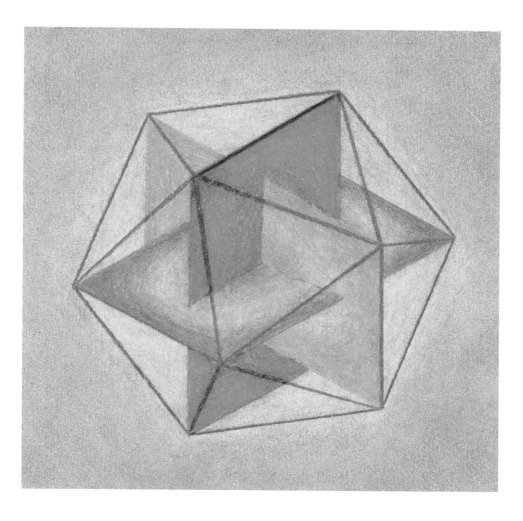

An icosahedron and the golden rectangles

The Golden Ratio

The line segment below was divided based on a golden ratio. The ratio of the longer side b and the shorter side a is the same as the ratio of the whole line segment c and the longer side b. This ratio is about 1.618, which means that the longer side is 1.618 times the length of the shorter side. If you write the ratio the other way around, so that it is the ratio of the shorter side a to the longer side b, you will get about 0.618. If you multiply the length of the whole line segment by 0.618, you will get the length of the longer side b. The Greek letter φ, phi, is often used as a symbol for the golden ratio.

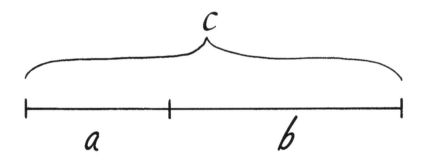

A line segment in a golden ratio, where

$$\frac{b}{a} = \frac{c}{b}$$

The Golden Ratio with a Ruler and Compass

You can use these instructions to draw the circles for drawing an icosahedron or a dodecahedron on pages 36–41. You will need a rather long pencil in your compass.

1. Draw a point and use it as the origin for a circle. Draw a horizontal diameter through the origin. Keep the compass open at the same radius and place the needle-point of the compass on the leftmost point of the diameter. Draw a semicircle that crosses the origin of the original circle.

2. Place the needle-point of the compass on the rightmost point of the diameter. Set the radius of the compass to the diameter of the circle. Draw an arc as in picture 2.

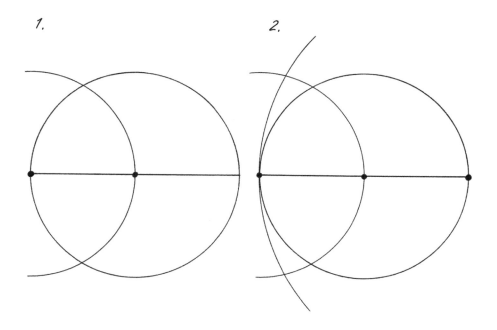

1.

2.

3. Find the point where the original circle and the semicircle meet in the upper part of the image. Then find the point where the previously drawn arc and the semicircle meet in the lower part of the image. Connect these two points.

4. The radius of the original circle has now been divided in the golden ratio. If you are drawing an icosahedron or a dodecahedron, place the needle-point of the compass on the origin of the circle. Set the radius of the compass to the distance between the origin and the point that divides the radius of the original circle. Draw a circle.

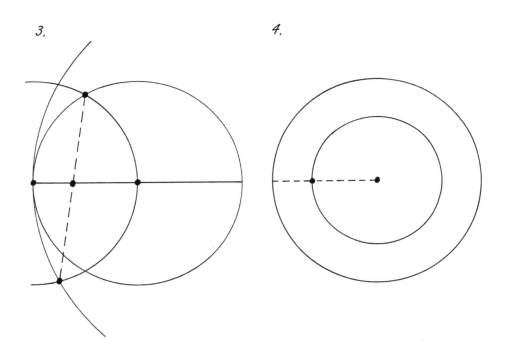

3.

4.

Drawing Symmetries with a Ruler and Compass

A Ruler and Compass Construction for Drawing a Regular Hexagon

You can draw the points of a regular hexagon with a compass. Draw a circle in the middle of the paper, with a radius of, for example, 3 inches (7.5 cm). Keep the compass open at the same radius throughout all of the steps. Draw a point anywhere on the outline of the circle and place the needle-point of the compass there. Draw a short arc that crosses the circle's outline. Move the needle-point of the compass to the point where the new arc and the circle meet. Keep drawing new arcs and moving the needle-point to the next intersection point until you have six marks along the circle's circumference. Connect the six marks on the circumference to form a regular hexagon.

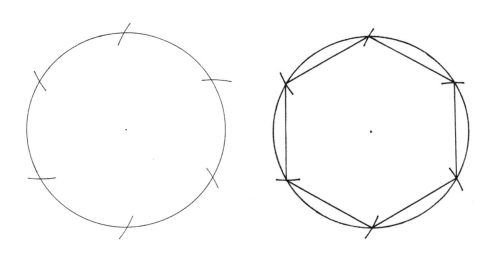

A Ruler and Compass Construction for Drawing a Regular Pentagon

1. Draw a point and use it as the origin for a circle, with a radius of, for example, 3 inches (7.5 cm). Draw a horizontal diameter through the origin. Place the needle-point of the compass on the leftmost point of the diameter. Increase the radius of the compass so that you can draw short arcs above and below the circle. Draw one arc above and another below the circle, as in picture 1. Keep the compass open at the same radius and move the needle-point to the rightmost point of the diameter. Draw two short arcs above and below the circle, as in picture 1. Connect the intersection points above and below the circle. You have now drawn a vertical diameter that is perpendicular to the horizontal diameter.

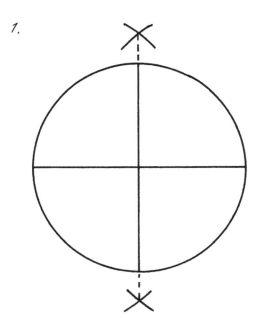

1.

2. Set the compass to the radius of the original circle. Place the needle-point of the compass on the rightmost point of the horizontal diameter. Draw an arc as in picture 2. Connect the two points where the new arc meets the outline of the circle. You have bisected the horizontal radius of the circle.

3. Move the needle-point of the compass to the point where the new vertical line crosses the diameter of the circle. Set the radius so that the compass reaches the uppermost point of the vertical diameter (the dashed line in picture 3). Draw an arc that crosses the horizontal diameter on the left.

2.

3.

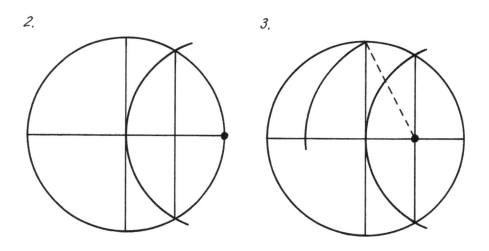

4. Move the needle-point of the compass to the uppermost point of the circle. Set the radius so that the compass reaches the point where the previously drawn arc crosses the horizontal diameter (the dashed line in picture 4). Draw two short arcs that cross the outline of the circle on the left and on the right.

Keep the radius of the compass the same. Move the needle-point to the point where the previously drawn left arc crosses the circumference. Draw a new short arc that crosses the outline of the circle. Repeat on the right side: Move the needle-point of the compass to the point where the right arc crosses the outline of the circle. Draw one more arc that crosses the outline of the circle. You have now drawn five marks along the circle's circumference.

5. Connect the five marks on the circumference to form a regular pentagon.

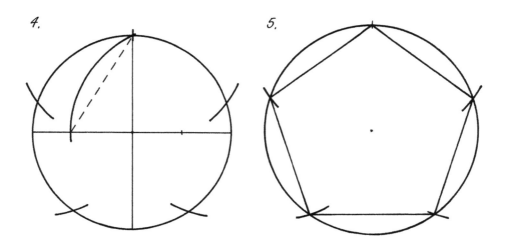

A Ruler and Compass Construction for Drawing a Regular Decagon

Complete steps 1–4 on previous pages to draw five marks along the circle's circumference.

Place a ruler over the picture so that the ruler touches the origin and one of the five marks drawn on the outline of the circle (the dashed line in the picture below). Draw a mark at the point where the ruler touches the circumference on the other side. Repeat until you have drawn five new marks along the circle's circumference. Connect the ten marks on the circumference to form a regular decagon.

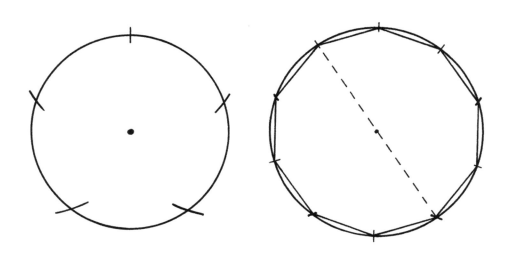

A Sixfold Symmetry Image

Draw a circle in the middle of the paper, with a radius of about 1.6 inches (4 cm) on an A4 sheet. Keep the compass open at the same radius throughout all of the steps.

1. Draw a point anywhere on the outline of the circle and place the needle-point of the compass there. Draw a circle. Move the needle-point of the compass to the point where the new circle and the original circle meet. Keep drawing new circles and moving the needle-point to the next intersection point until you have drawn six new circles.

2. Place the needle-point of the compass at the point where any of the two previously drawn circles meet at the outer edge of the image. Draw an arc that remains wholly inside the image.

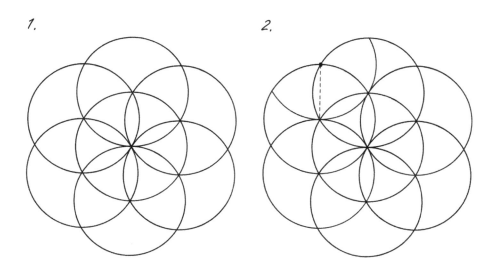

1.

2.

3. Repeat step 2 for the five remaining similar intersection points.

4. Place the needle-point of the compass on the outermost intersection point of the image. Draw an arc that remains wholly inside the image. Repeat for the five other similar intersection points.

3.

4.

A sixfold symmetry image

How many faces, vertices and edges?

The tables below show how many faces, vertices and edges there are in the Platonic solids and solids in the series on pages 16–25. Like all convex polyhedra, these solids follow Euler's polyhedron formula. Let's mark the number of faces with F, the number of vertices with V, and the number of edges with E. We can then write Euler's polyhedron formula as $V + F = E + 2$.

Platonic solid	Faces F	Vertices V	Edges E
Tetrahedron	4	4	6
Cube	6	8	12
Octahedron	8	6	12
Icosahedron	20	12	30
Dodecahedron	12	20	30

Solid in the transformation series	Faces F	Vertices V	Edges E
Cube	6	8	12
Truncated cube	14	24	36
Cuboctahedron	14	12	24
Truncated octahedron	14	24	36
Octahedron	8	6	12

Instructions for Teachers

You can give your students written instructions from the book or draw the shape as an example on a board. The difficulty levels of the drawings are given in the rightmost column of the table on the following pages. The table also shows you which pages are needed to draw a particular image and the recommendations for lengths to be used on larger A3 sheets.

Creating a Display on a Classroom Wall

Divide your students into groups of 2–3. If possible, arrange for at least one sufficiently skilled student to help the others in each group. Give each group written instructions on how to draw a solid. You can let them choose which solid they will draw, or give them instructions according to the group's skill level. They can use either A4 or A3 sheets. Each student will draw one picture. The members of each group will explore the instructions together, helping each other to understand them.

Every group needs a few colored pencils. Encourage them to color the whole picture, including the background. You can instruct them on the different coloring techniques given on page 4. It is also possible to obtain an attractive background by coloring with the long side of a crayon – students can start by cleaning the crayon by doing a little coloring on an empty sheet of paper.

The finished pictures can be hung on the wall in series, so that the images belonging to the transformation series follow each other in sequence.

Image	Pages	Lengths on an A3 sheet	Skill level
Tetrahedron from a model	(66, 69)		1
Tetrahedrons	7–9 (66, 69)		3
Tetrahedron	10–11, 16	see cube	1
Tetrahedrons	10, 12–13, 16	see cube	3
Cube	16–17	edge 6 inches (15 cm), depth 3 inches (7.5 cm)	1
Truncated cube	16, 18–19	point 1.8 inches (4,4 cm), depth 0.9 inches (2,2 cm)	2
Cuboctahedron	16, 20–21	see cube	2
Truncated octahedron	16, 22–23	point 1.5 inches (3.8 cm), depth 0.75 inches (1.9 cm)	3
Octahedron	16, 24–25	see cube	2
Cube inside an octahedron	16, 24, 26, 7–8	see cube	3
Stellated octahedron	27–28, 51	radius 4 inches (10 cm)	3
Small stellated dodecahedron	29–31	radius 4 inches (10 cm)	3

Great stellated dodecahedron	32–35	radius 4 inches (10 cm)	3
Dodecahedron	36–38	radiuses 2.47 inches (6.2 cm) and 4 inches (10 cm)	3
Icosahedron	39–41	radiuses 2.47 inches (6.2 cm) and 4 inches (10 cm)	3
Dodecahedron inside an icosahedron	39–41, 42–43	radiuses 2.47 inches (6.2 cm) and 4 inches (10 cm)	5
Icosahedron inside a dodecahedron	39–41, 42–43, 44–45	radiuses 2.47 inches (6.2 cm) and 4 inches (10 cm)	5
Icosahedron and the golden rectangles	39–41, 46-47	radiuses 2.47 inches (6.2 cm) and 4 inches (10 cm)	4
Sixfold symmetry image	56–58	radius 2.2 inches (5.5 cm)	2

Appendix 1: Pictures by Kepler

Johannes Kepler (1571–1630), a famous German astronomer, discussed many geometric solids in his book *The Harmony of the World*, which was originally published in Latin in 1619 as *Harmonices Mundi*. Below are his drawings of the small and great stellated dodecahedron.

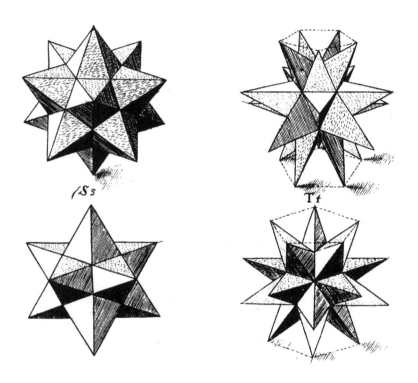

On the left is a small stellated dodecahedron shown from two perspectives. On the right, you can see a great stellated dodecahedron, also shown from two perspectives.

Pictured below are Kepler's illustrations of the Platonic solids, where he added the elements suggested by Plato (c.427–347 BC). Plato associated the Platonic solids with the elements that he thought the world was composed of. The tetrahedron stood for fire, octahedron for air, cube for earth, and icosahedron for water. The dodecahedron represented the creation of the heavens.

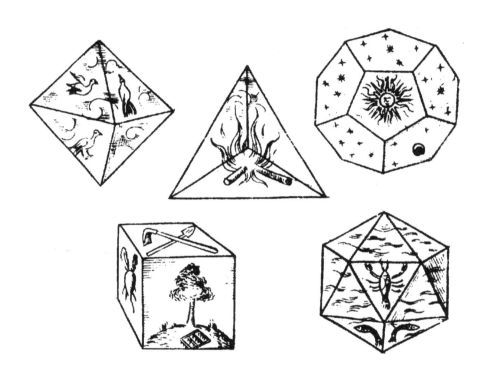

From the top left: an octahedron, a tetrahedron, a dodecahedron, a cube and an icosahedron

Kepler also drew dual solids inside the Platonic solids. You will get the picture on the right by drawing a dodecahedron on pages 36–38, finding the middle points of the faces, and connecting them to form an icosahedron.

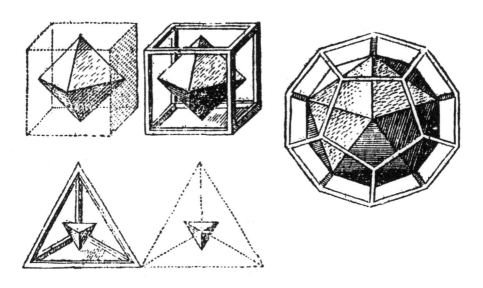

Top left an octahedron inside a cube, bottom left a tetrahedron inside a tetrahedron, and on the far right an icosahedron inside a dodecahedron

Appendix 2: Building a Tetrahedron

Start by cutting along the outer edge of the template on the next page. Write the numbers on the picture below on the back of the template.

Fold along the edges of all triangles of the template, with the intended outside faces showing on the outside. Then, glue as instructed below. When you glue one face, press it together with your fingers and count slowly to 15. Then glue the next face of the solid.

Glue quadrilateral 1 under triangle 1. Then glue triangles 2 on top of each other. Finally, glue triangles 3 on top of each other.

Alternatively, you can draw the template on another paper or cardboard with a protractor. The angles of the triangles are 60 degrees. If you use 2.9 inches (7.3 cm) for the side of one triangle, you will get about 2.4 inches (6 cm) high tetrahedron.

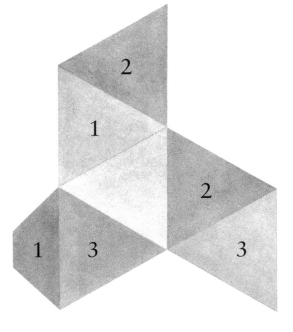

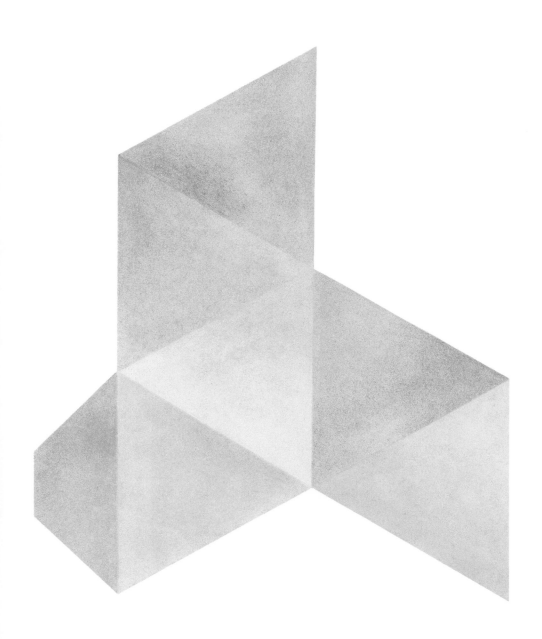

Literature

(in approximate order from simple to complex)

Coloring Geometric Images, Sympsionics Design, Deltaspektri, 2014

Building Platonic Solids: How to Construct Sturdy Platonic Solids from Paper or Cardboard and Draw Platonic Solid Templates With a Ruler and Compass, Sympsionics Design, Second Edition, Deltaspektri, 2015

Drawing Circle Images: How to Draw Artistic Symmetrical Images with a Ruler and Compass, Musigfi Studio, Deltaspektri, 2014

Platonic and Archimedean Solids, Daud Sutton, Wooden Books, 2005

Ruler and Compass: Practical Geometric Constructions, Andrew Sutton, Wooden Books, 2009

Platonische und Archimedische Körper, ihre Sternformen und polaren Gebilde, Paul Adam & Arnold Wyss, Freies Geistesleben, 1984

Polyhedra, Peter R. Cromwell, Cambridge University Press, 1997

Other Books from Deltaspektri

Drawing Circle Images: How to Draw Artistic Symmetrical Images with a Ruler and Compass

From simple to complex — use a compass to draw fascinating artistic images. This book includes step-by-step instructions for all symmetries between threefold and twelvefold. Clear and precise black-and-white illustrations will guide you. The book provides ruler and compass constructions that you can draw without using units of measurement for three-, four-, five-, six-, eight-, ten- and twelvefold symmetries. In addition, it gives dimensions in inches (and cm) for all images, which you can use on both A4 and A3 sheets.

Building Platonic Solids: How to Construct Sturdy Platonic Solids from Paper or Cardboard and Draw Platonic Solid Templates With a Ruler and Compass

How can you build sturdy Platonic solids that will hold together through to the last gluing? The templates in this book were designed to answer that question. You can build the solids directly from the templates, or use them as a model to build on colored paper, cardboard, or paper you have colored or painted yourself.

Includes 3 x 5 black-and-white templates for building Platonic solids and instructions, and the second edition includes also detailed instructions with clear step-by-step images on how to draw the templates with a ruler and compass.

Coloring Geometric Images

This full colored book contains numerous instructions and illustrated examples of colored pencil techniques that are useful when coloring geometric images. It also includes instructions on how to draw three pictures for coloring.

Coloring
Geometric Images

In addition, you will find blue outlines of captivating, three-dimensional geometric shapes for coloring. You can use these as models for drawing the same shapes on your own paper. Included are an octahedron inside a cuboctahedron, a great stellated dodecahedron from two angles, three intersecting planes, a dodecahedron inside an icosahedron, an icosahedron inside

a dodecahedron, a transparent rhombic dodecahedron and a small stellated dodecahedron from two angles. Each of these shapes is presented twice, with the first one already colored to help you visualize its form.

CPSIA information can be obtained
at www.ICGtesting.com
Printed in the USA
BVHW02s0548180618
519091BV00007B/11/P

9 789526 821733